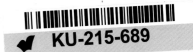

BEWARE of the BEARS!

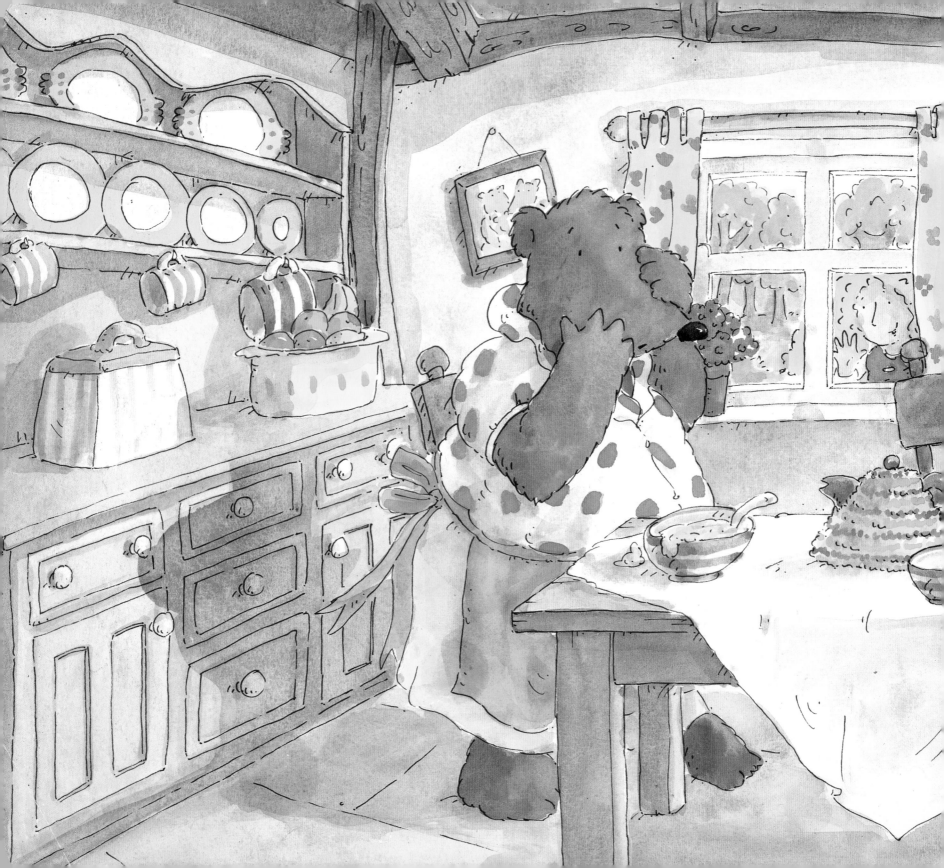

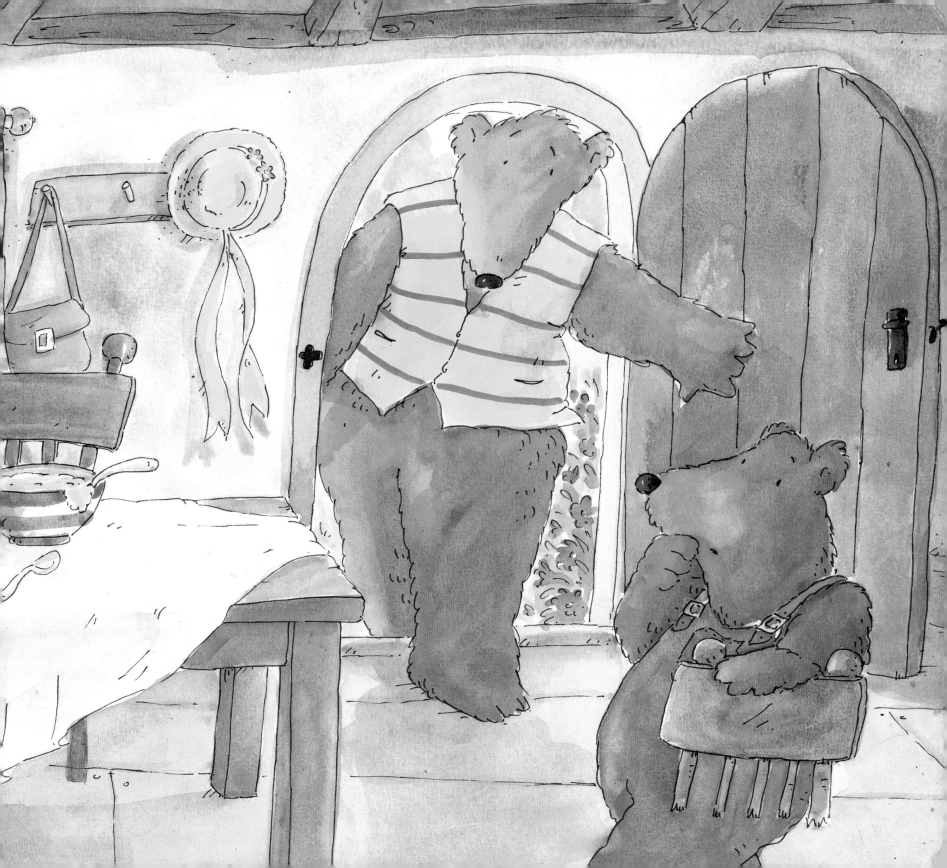

To Bridie
A.M.

To Alice with love
G.W.

This paperback edition published 1998

First published 1998 by Magi Publications
22 Manchester Street, London W1M 5PG

Text © 1998 Alan MacDonald
Illustrations © 1998 Gwyneth Williamson

Alan MacDonald and Gwyneth Williamson have
asserted their rights to be identified as the author
and illustrator of this work under the Copyright,
Designs and Patents Act, 1988.

Printed and bound in Belgium by
Proost NV, Turnhout

ISBN 1 85430 457 7

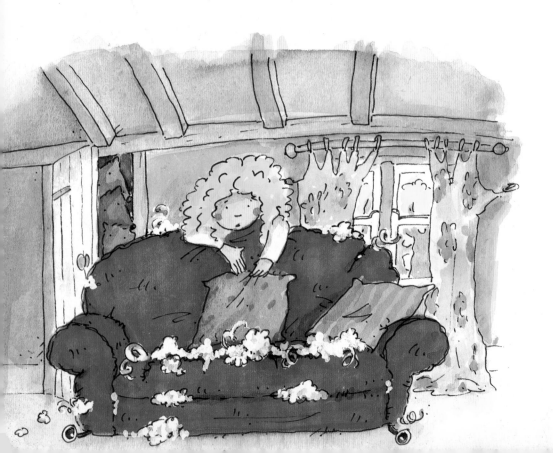

BEWARE of the BEARS!

by Alan MacDonald

illustrated by Gwyneth Williamson

When the three bears saw what Goldilocks
had done to their little cottage, they were
hopping mad.
Their porridge eaten!
Chairs broken!
Beds bounced on!
"Go after her! Find out where she lives!"
ordered Daddy Bear.

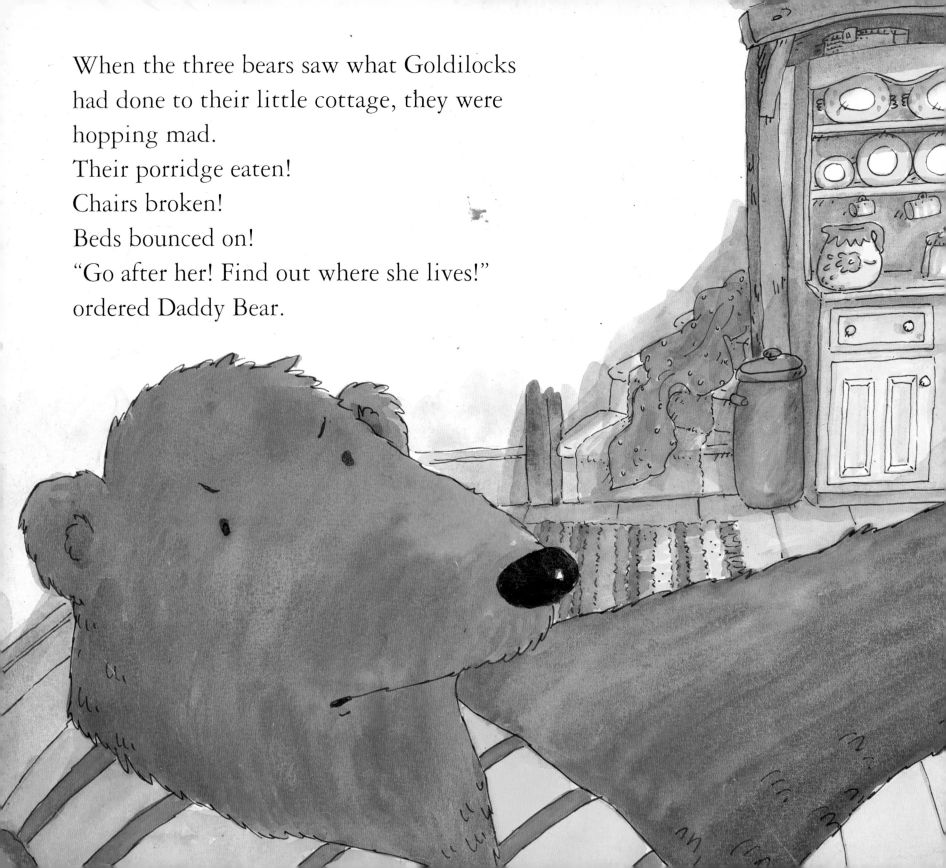

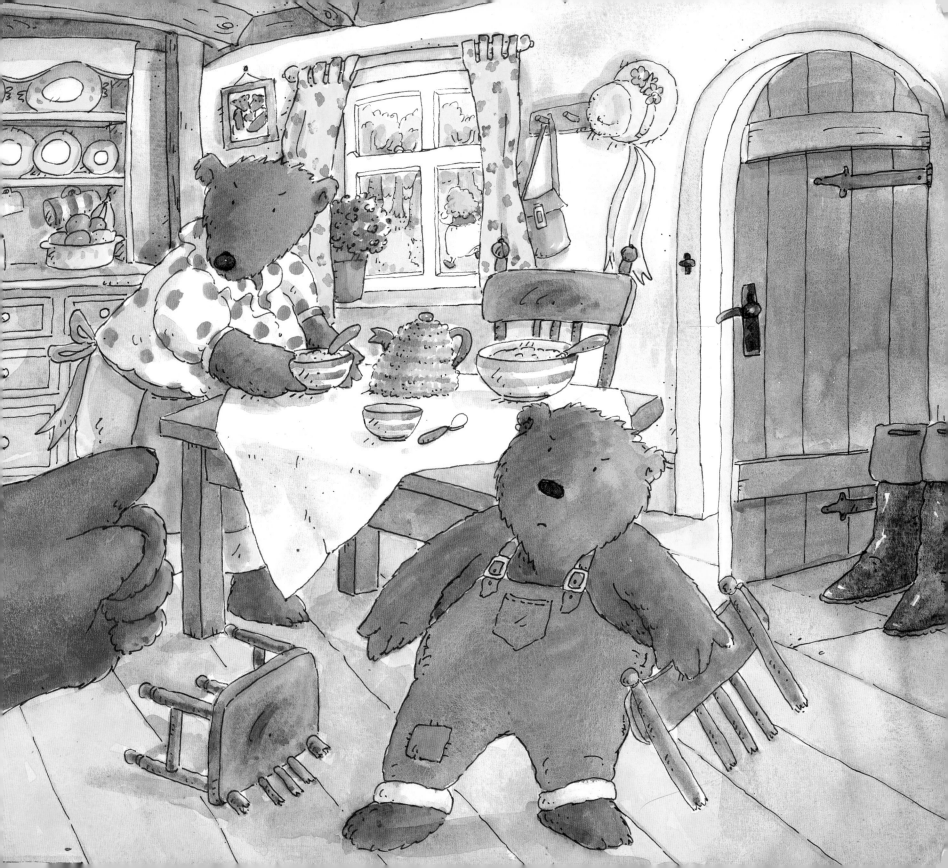

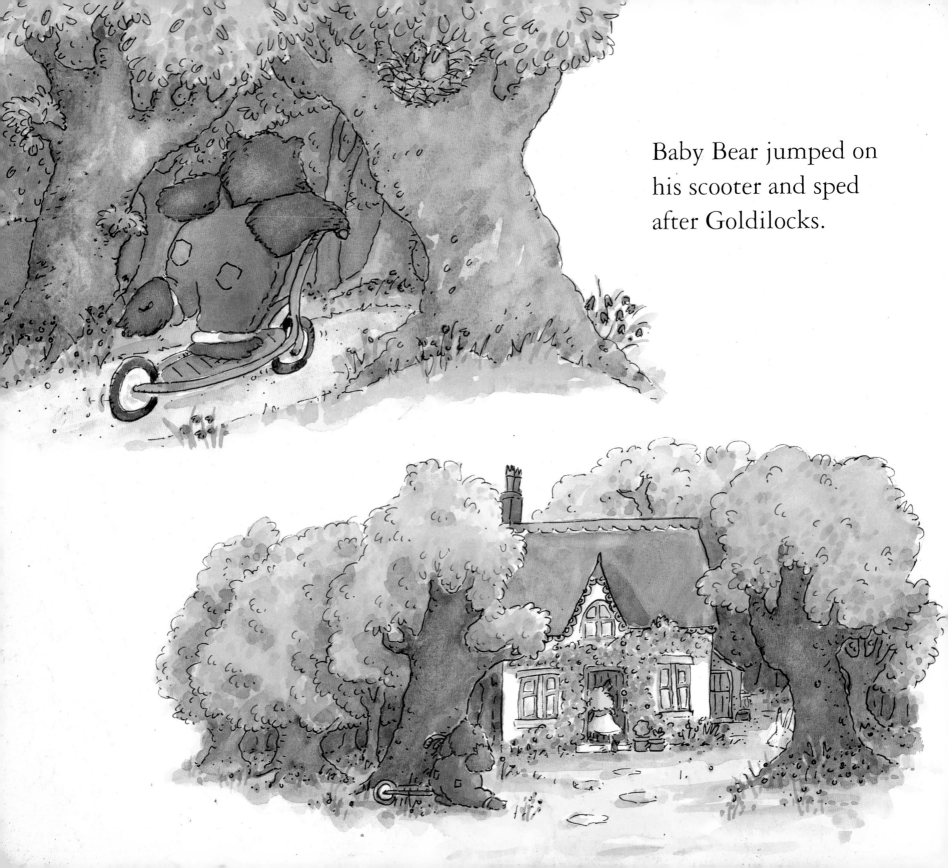

Baby Bear jumped on
his scooter and sped
after Goldilocks.

In no time at all he was back.
"She lives on the far side of the forest,"
panted Baby Bear. "And what's more,
she's just gone out again and left
her door unlocked."
"Good!" said Mummy Bear.
"What are we waiting for?
Let's see how *she* likes having
uninvited guests."

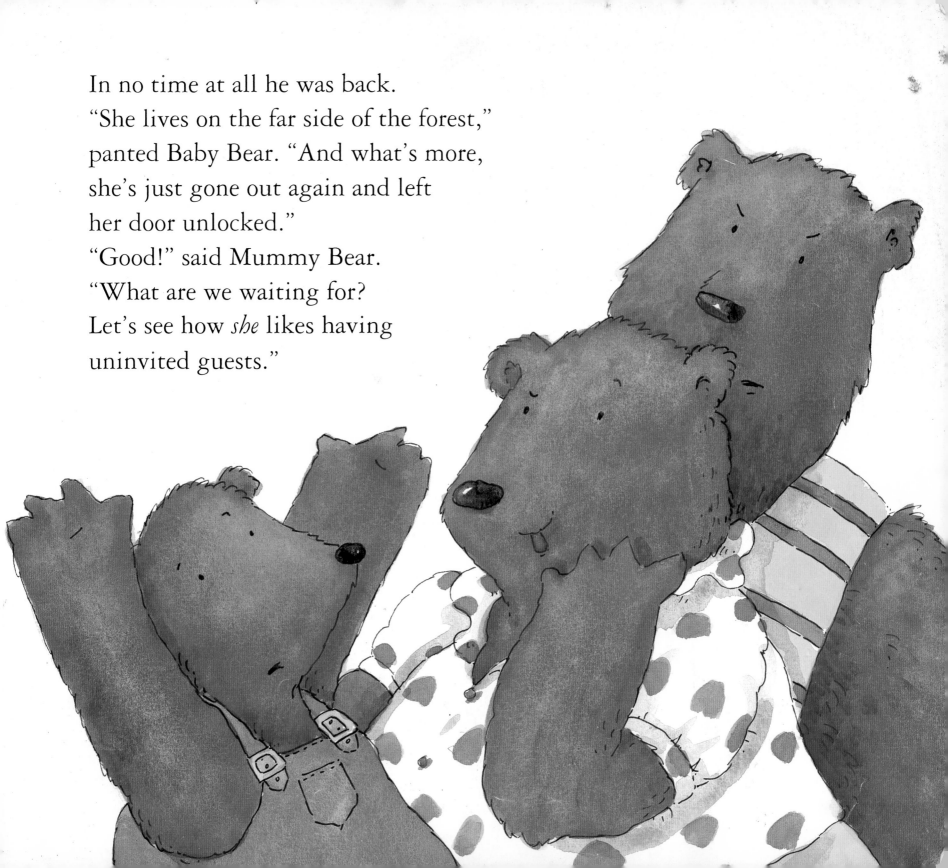

Baby Bear led the way through the forest to Goldilocks' cottage. The door was unlocked, just as he'd said.

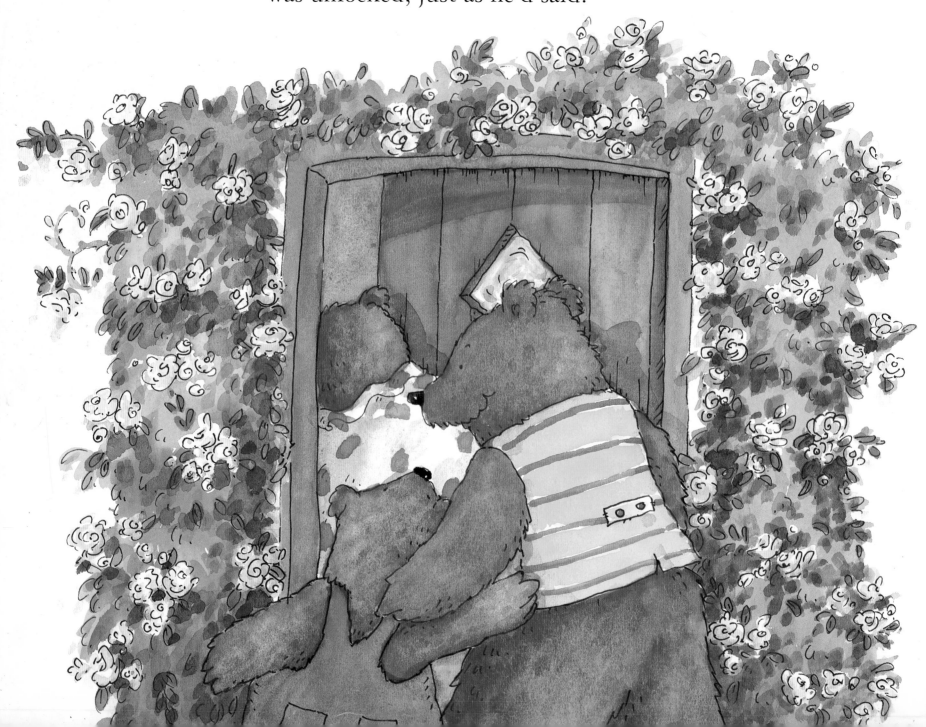

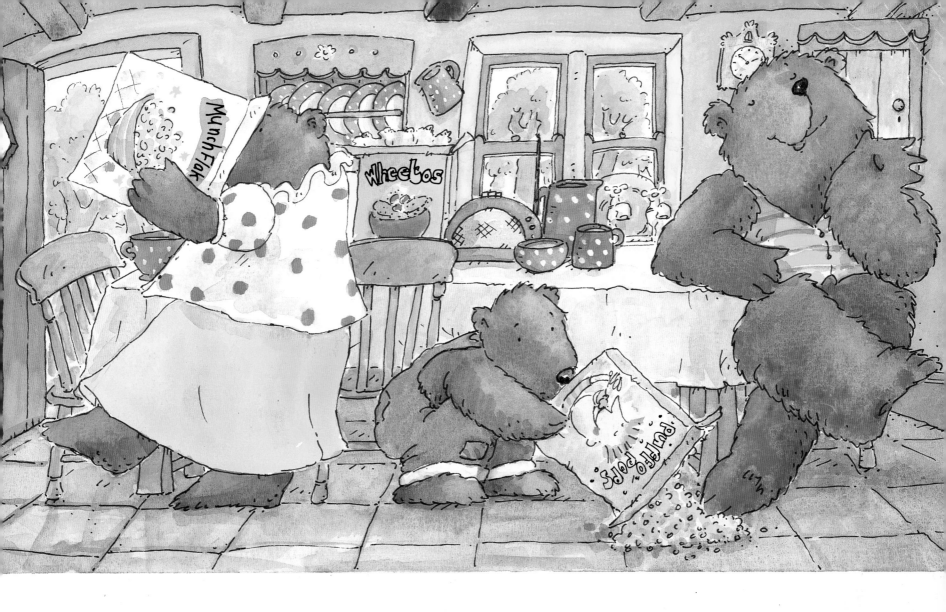

On the breakfast table were several open packets.
"This isn't porridge," sniffed Mummy Bear.
Baby Bear read the labels. "Wheetos, Munch
Flakes and Puffo Pops."
"Sounds all right to me," said Daddy Bear. "Pour
away, Baby-o!"

"These Wheetos are too sweet," said Daddy Bear.
"These Munch Flakes are too noisy," said
Mummy Bear.
"But these Puffo Pops are just right," said Baby
Bear, catapulting a spoonful towards Daddy Bear.

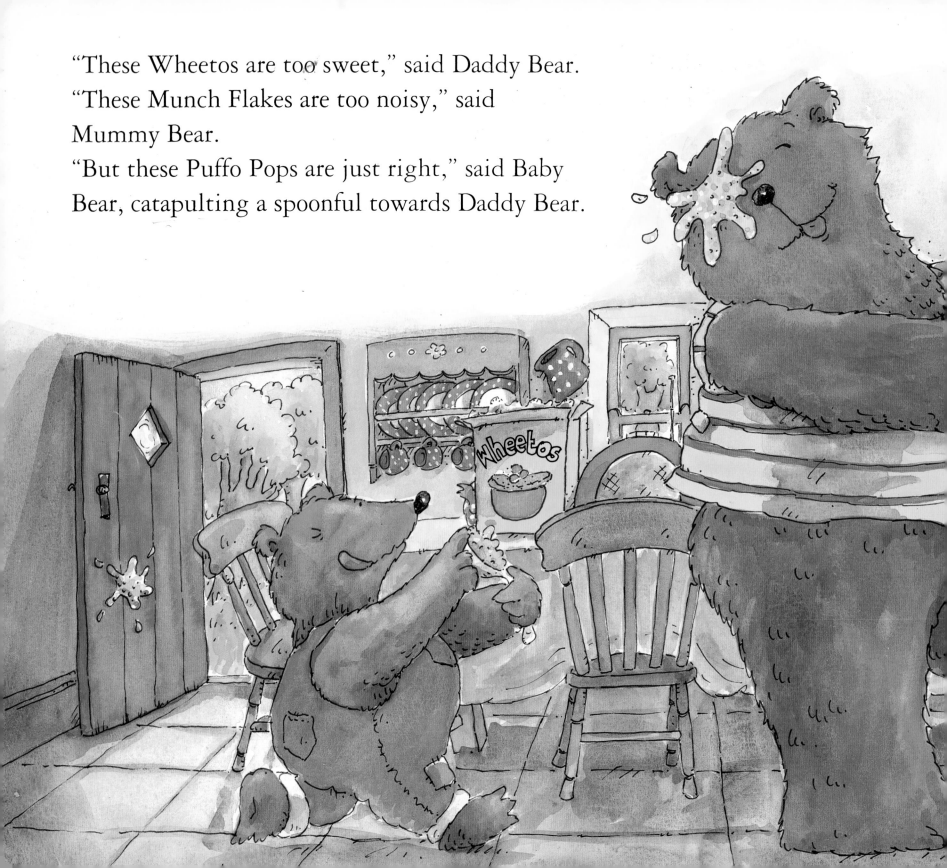

A Puffo Pop hit Daddy Bear in the eye. He sent
back a spoonful of Wheetos. They splattered all
over Mummy Bear's best blouse.
Soon cereal was flying left and right, till the carpet,
the walls and the ceiling were dripping with
brown goo.

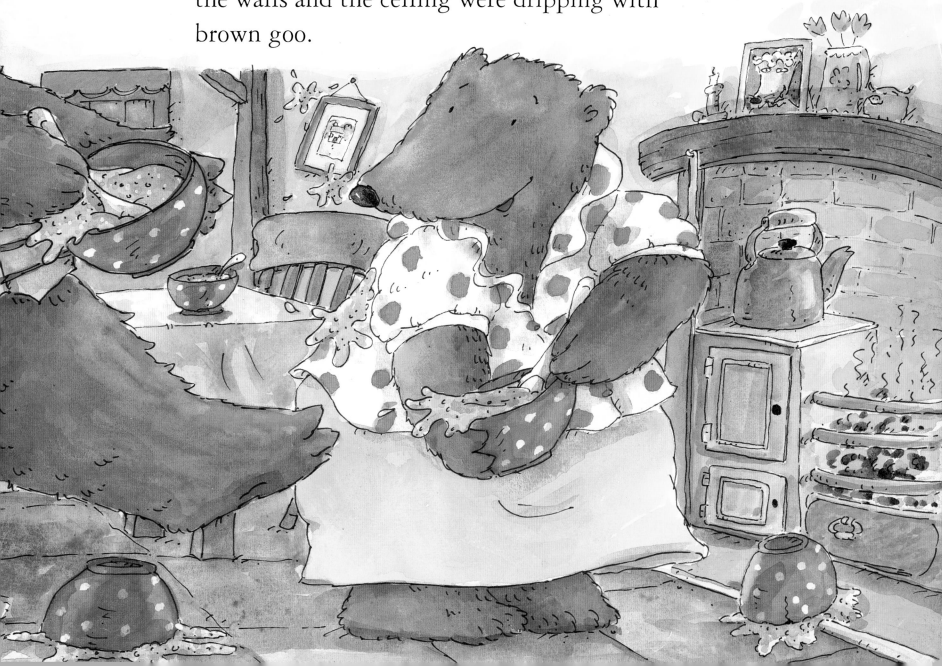

Baby Bear turned on the radio.
"Let's dance!" he squealed.

Mummy and Daddy
Bear tangoed on the
table.
"This table's too slippy,"
said Daddy Bear.

They did the cha-cha round
the curtains.
"These curtains are
too rippy," said
Mummy Bear.

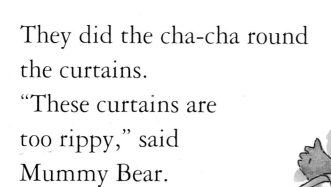

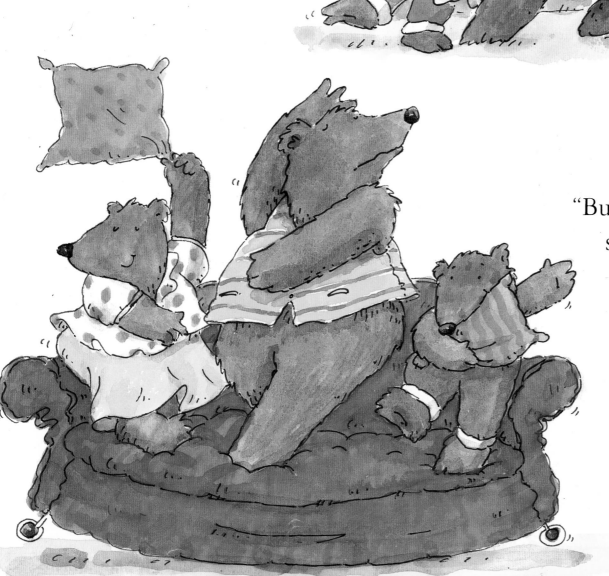

"But this sofa's just right,"
squeaked Baby Bear,
so they all jumped
on the sofa and did
the bossa nova
until

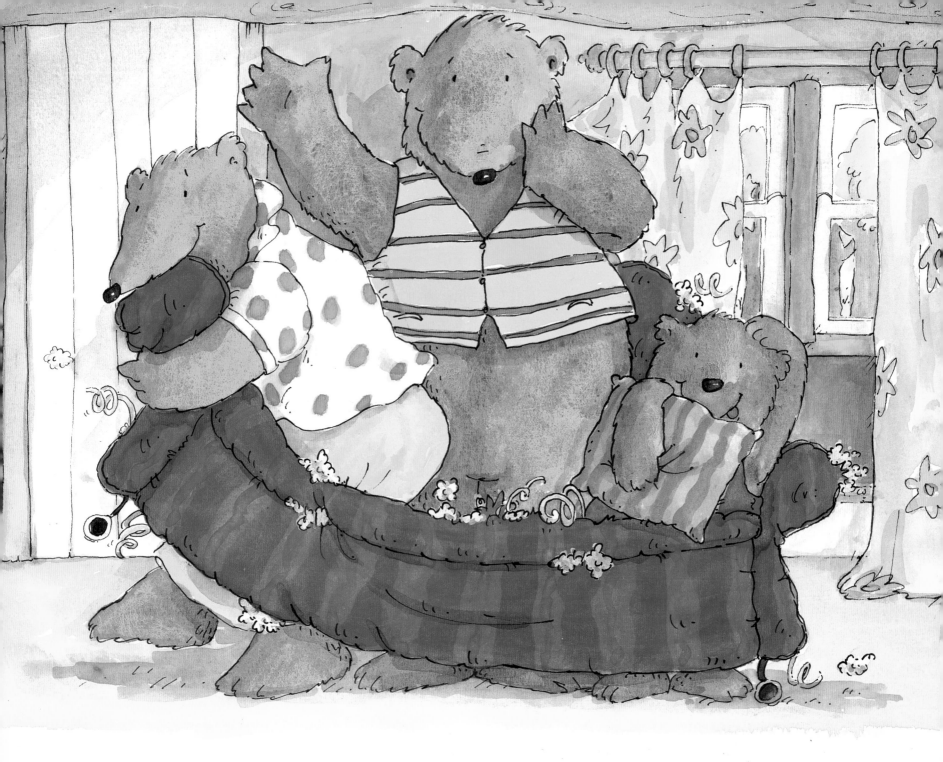

. . . they went right through it!

Next the three bears looked upstairs.
There were lots of things to try
in the bathroom.
"The shaving soap's too soapy,"
grumbled Daddy Bear.

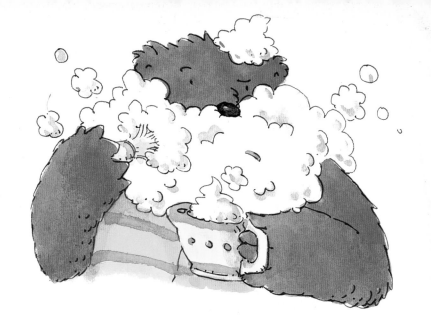

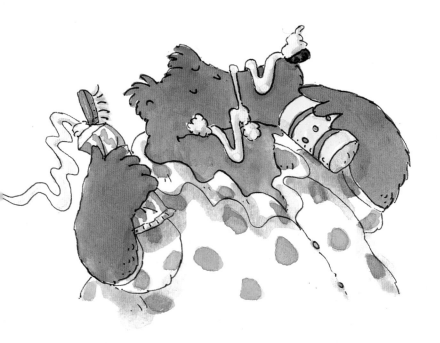

"This toothpaste's too minty,"
gargled Mummy Bear.

"But this bubble bath is just right,"
murmured Baby Bear from beneath
a mountain of suds.
"All right, here we come," said
Mummy Bear . . .

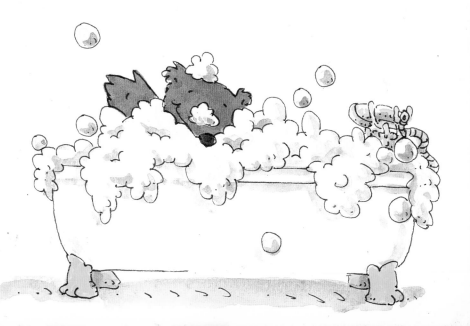

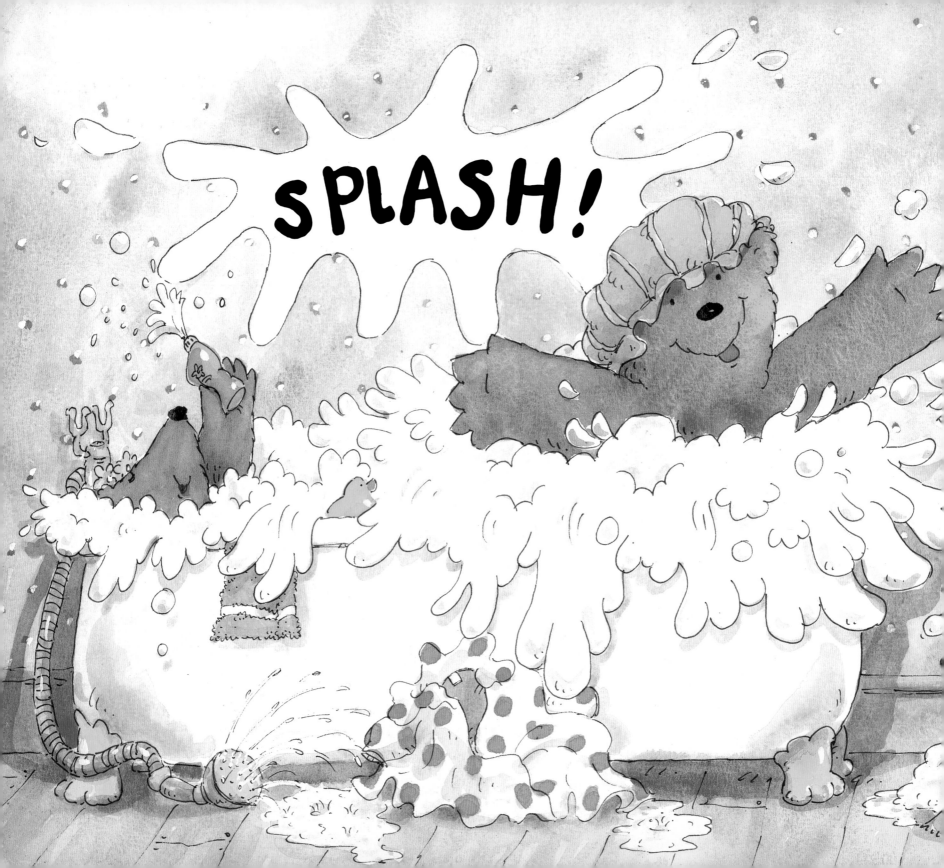

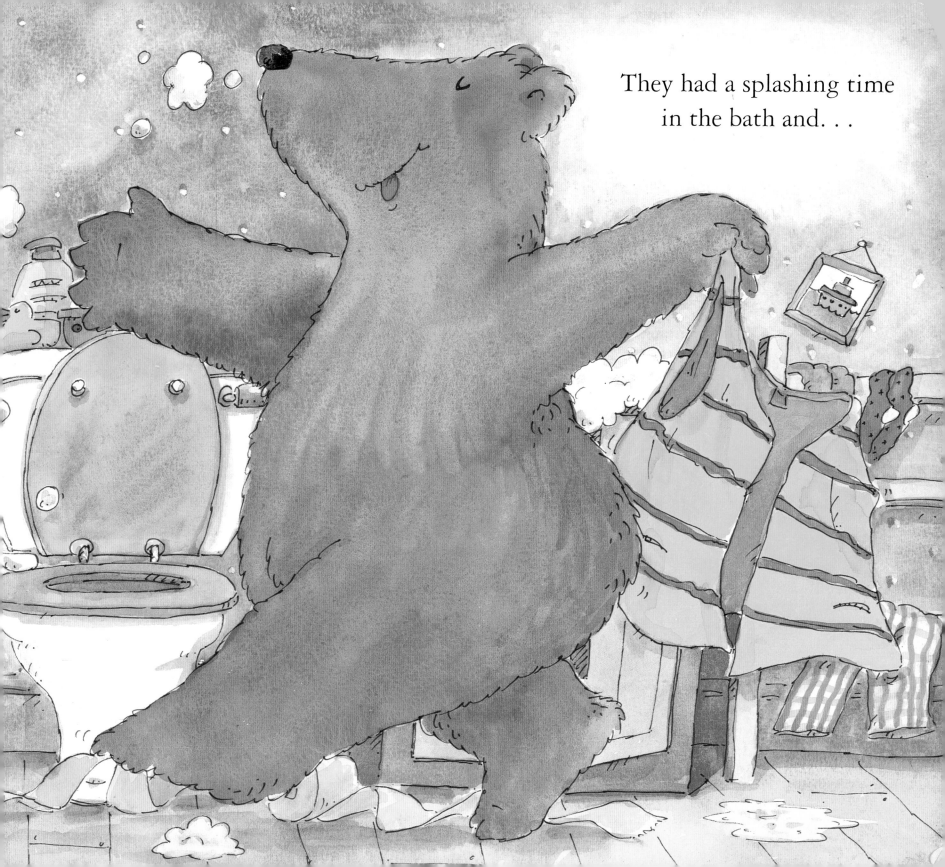

They had a splashing time
in the bath and. . .

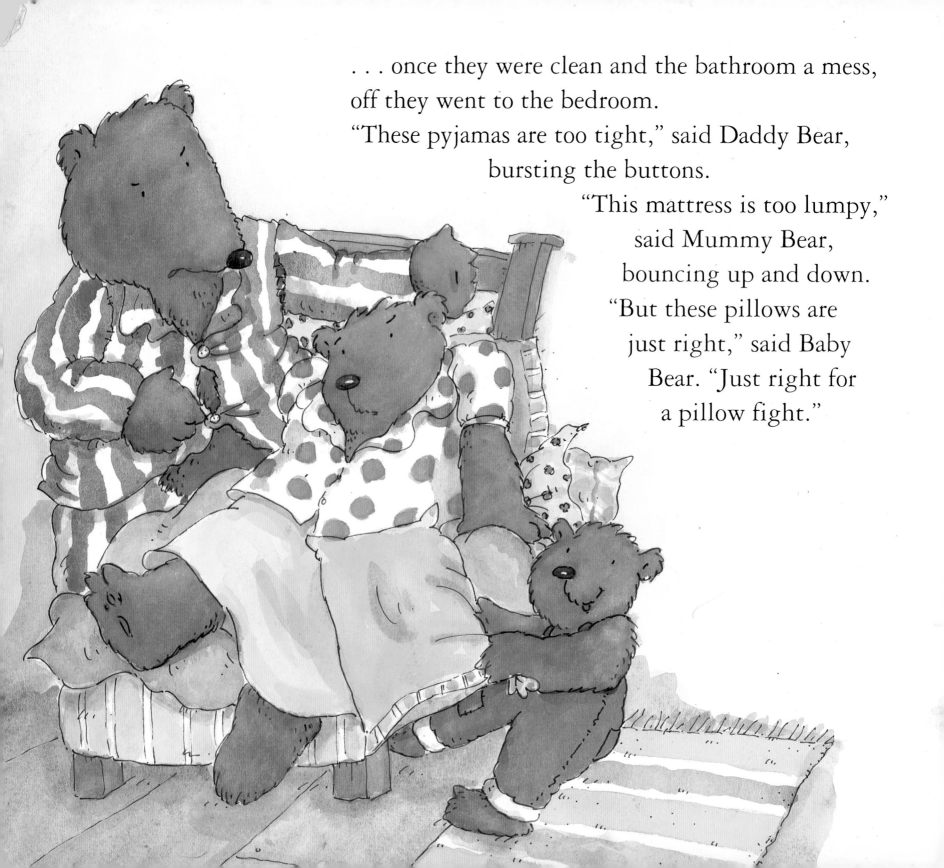

. . . once they were clean and the bathroom a mess, off they went to the bedroom.

"These pyjamas are too tight," said Daddy Bear, bursting the buttons.

"This mattress is too lumpy," said Mummy Bear, bouncing up and down.

"But these pillows are just right," said Baby Bear. "Just right for a pillow fight."

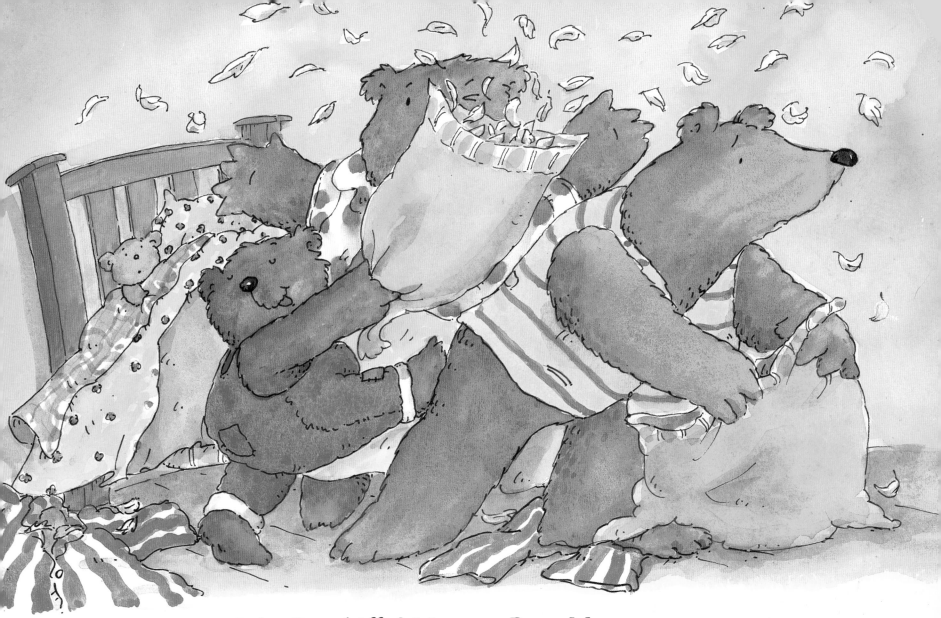

Baby Bear biffed Mummy Bear. Mummy
Bear whacked Daddy Bear. Pillows burst,
filling the air with clouds of feathers.
Till suddenly Daddy Bear stopped.
"Listen!" he said. "I hear someone."
Quietly, the three bears crept downstairs . . .

Goldilocks was in the kitchen.
Gleefully, Daddy Bear, Mummy
Bear and Baby Bear watched from
behind the door.
Goldilocks gasped when she saw the
cereal splattered all over the walls.

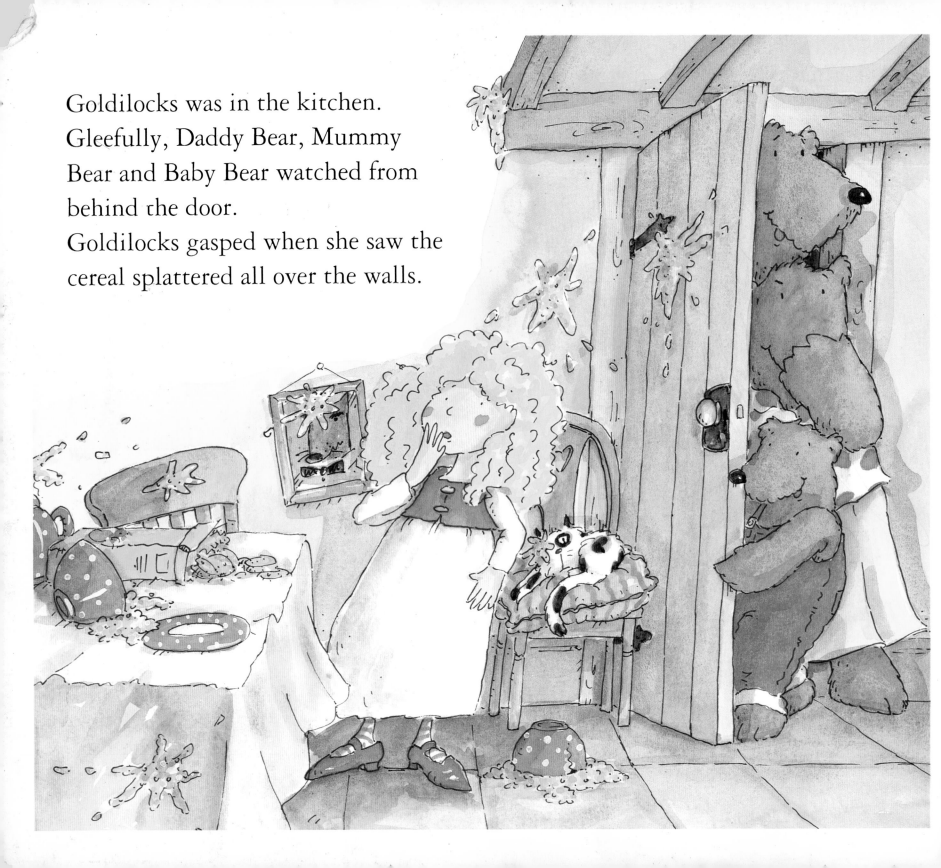

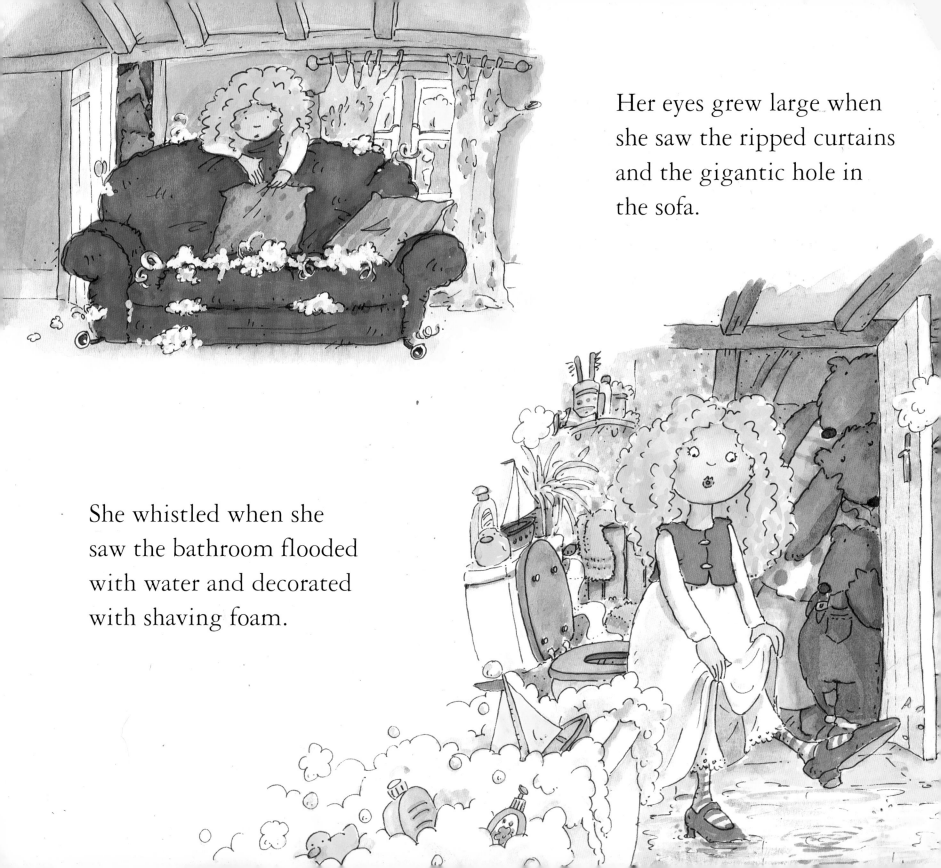

Her eyes grew large when
she saw the ripped curtains
and the gigantic hole in
the sofa.

She whistled when she
saw the bathroom flooded
with water and decorated
with shaving foam.

Next Goldilocks went into the bedroom.
She stared open-mouthed at the sea of
feathers and the burst bedsprings.
Then suddenly the three bears jumped
out from behind the door.

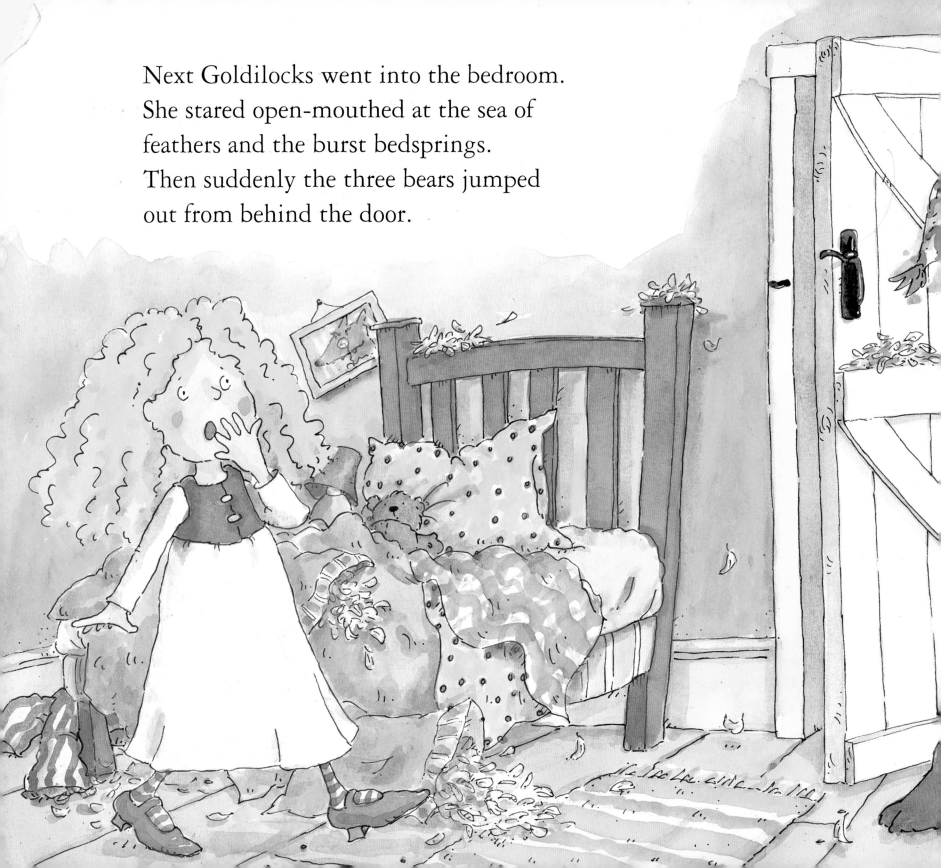

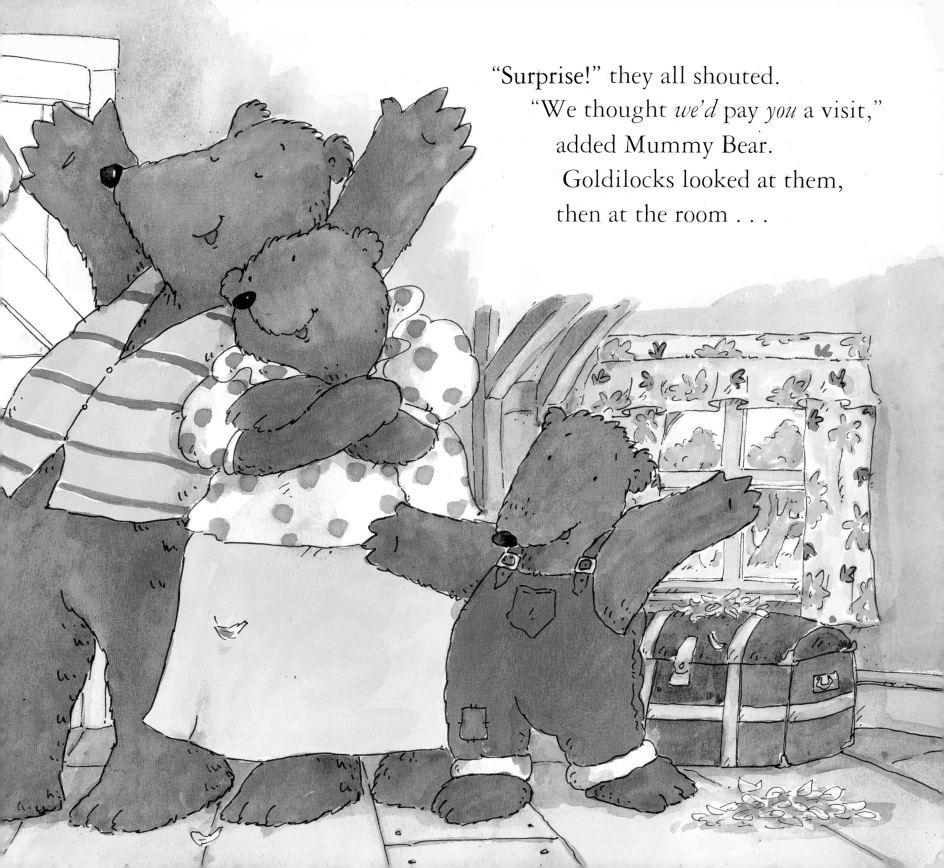

"Surprise!" they all shouted.
"We thought *we'd* pay *you* a visit,"
added Mummy Bear.
Goldilocks looked at them,
then at the room . . .

. . . and to the bears' astonishment, she threw back her head and laughed and laughed until her hair shook like golden springs.

"But aren't you mad at what we've done to your house?" asked Daddy Bear.

"*My* house? This isn't my house," giggled Goldilocks.

"But it must be," said Baby Bear. "I saw you go in."

"Oh that," said Goldilocks. "The door was open, so I thought I'd have a nose around. I'm always sneaking into other people's houses. I only came back because I left teddy behind."

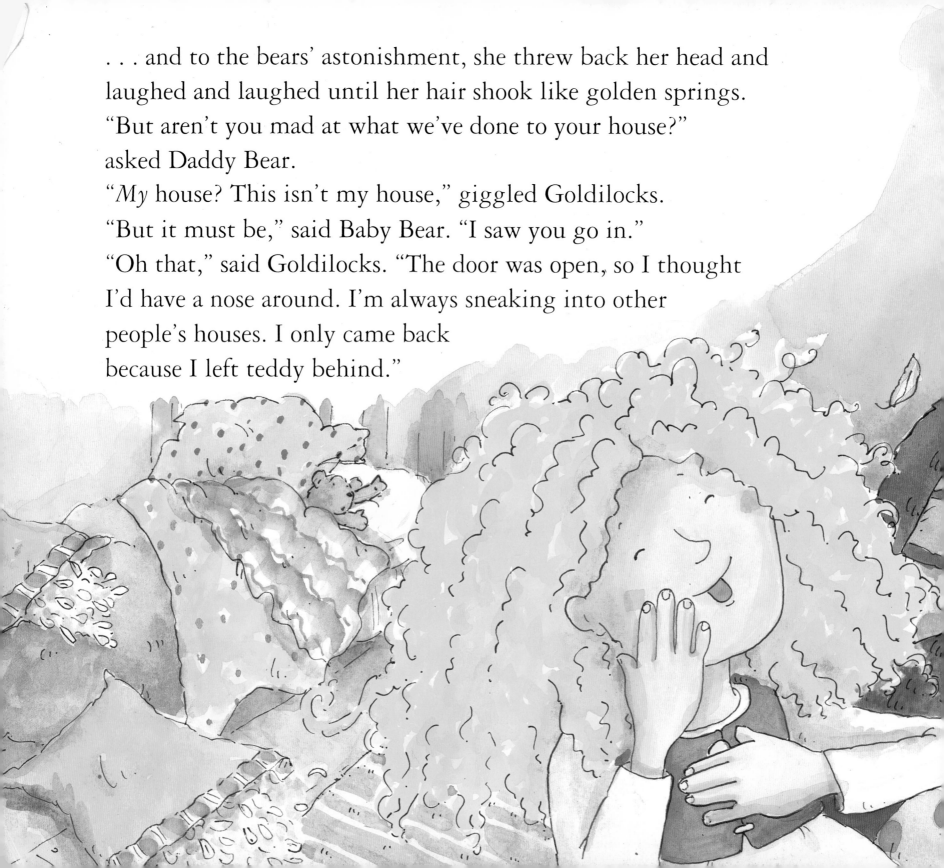

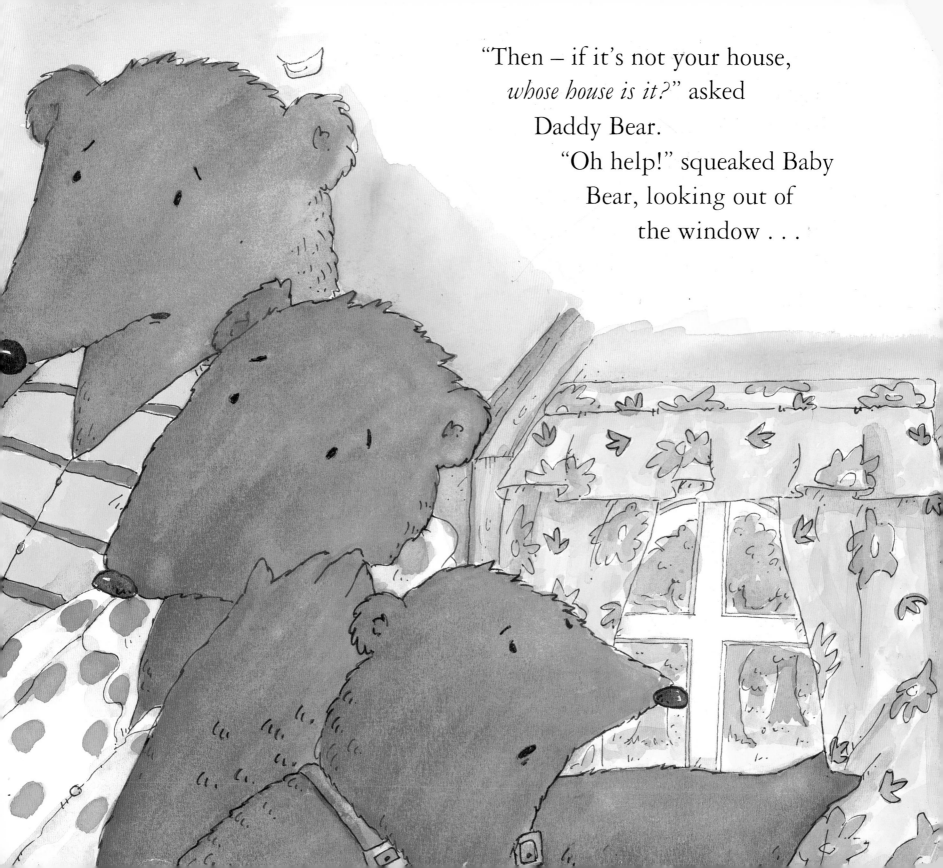

"Then – if it's not your house, *whose house is it?*" asked Daddy Bear.

"Oh help!" squeaked Baby Bear, looking out of the window . . .

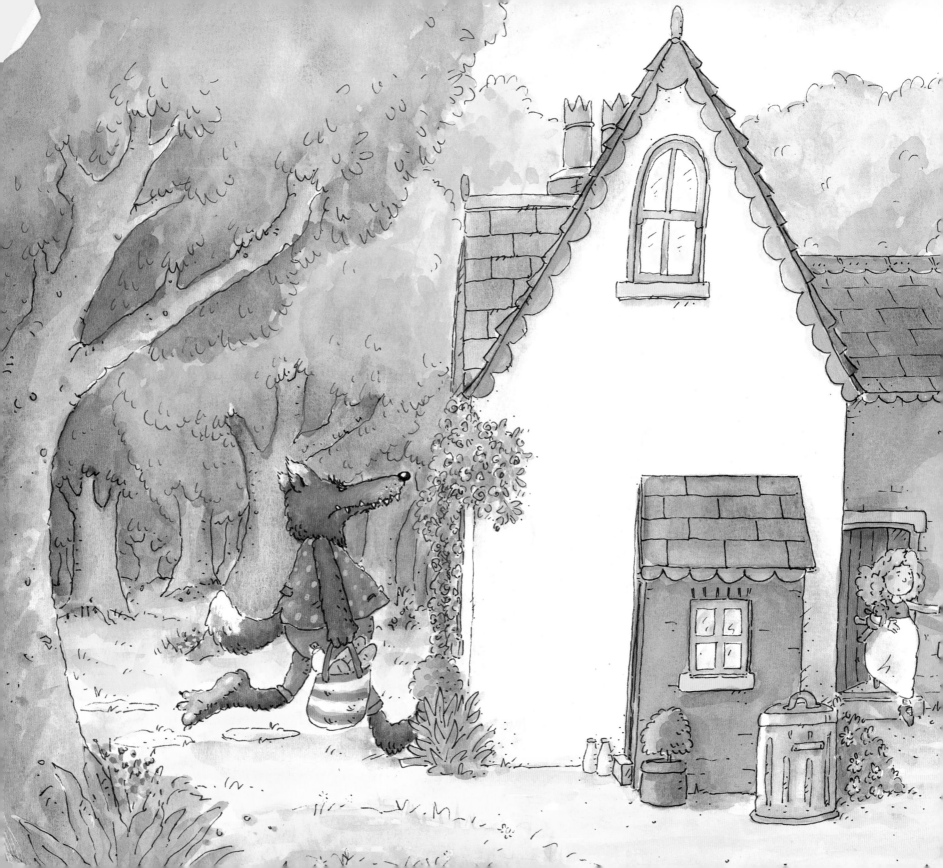

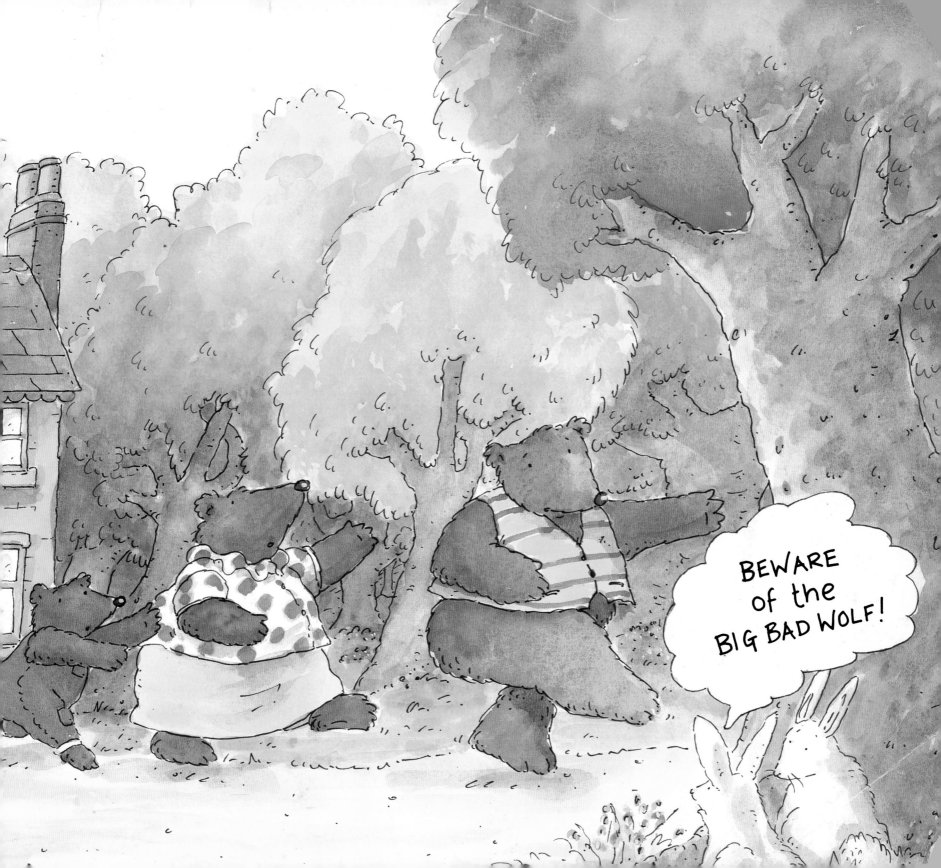

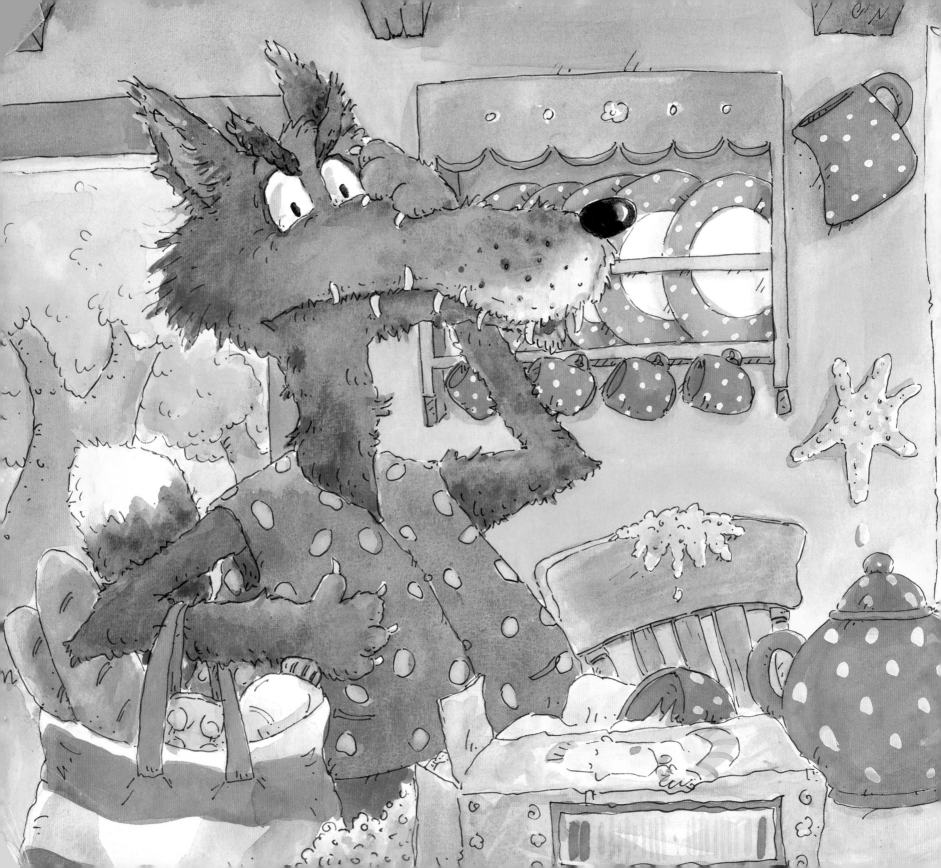